DRAWING MADE FUN

CATS

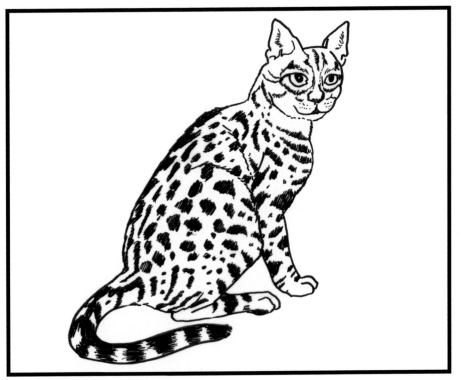

Robin Lee Makowski

Rourke
Publishing LLC
Vero Beach, Florida 32964

www.rourkepublishing.com

All illustrations Robin Lee Makowski.

Editor: Frank Sloan

Cover design by Nicola Stratford

Library of Congress Cataloging-in-Publication Data

Makowski, Robin Lee.
 Cats / written and illustrated by Robin Lee Makowski.
 p. cm. -- (Drawing made fun)
 Includes bibliographical references and index.
 ISBN 1-59515-468-X (hardcover)
 1. Cats in art--Juvenile literature. 2. Drawing--Technique--Juvenile
literature. I. Title.
 NC783.8.C36M3493 2006
 743.6'9752--dc22

 2005010403

Printed in the USA

CG/CG

Rourke Publishing
1-800-394-7055
www.rourkepublishing.com
sales@rourkepublishing.com
Post Office Box 3328, Vero Beach, FL 32964

INTRODUCTION

Drawing is a skill that is fun and useful, and something everyone wants to learn how to do better.

The step-by-step instructions in this book will help you first to see what you want to draw. Then you can place the parts correctly so your finished drawing looks the way you want it to. Of course, the only way to perfect your drawing skills is to practice, practice, practice!

If the drawing doesn't look right the first time, draw it again. It can be frustrating if the finished drawing doesn't look the way you wanted it to and you don't know how to fix it.

Follow the instructions and have fun learning how to draw your favorite cats!

MATERIALS

The two most common problems with drawing are not seeing how the parts of the object line up and using the wrong materials. The first problem will be solved with practice. The second problem is much easier to fix. You'll have a lot more fun and success with your drawings if you're not fighting with hard pencils, dry erasers, and thin paper.

These materials are available almost anywhere and will make your practice much easier:

<u>Best to Use</u>

Soft Pencils (#2B or softer)
Thick and Thin Drawing Pens
Soft White Eraser or Kneaded Eraser
Pencil Sharpener
Drawing Paper Tablet
Tracing Paper
Wax-Free Graphite Paper (helpful but not necessary)
Crayons or Colored Pencils or Colored Markers

<u>More Difficult to Use</u>

Typing or Computer Paper
Hard or Pink Erasers
Hard Pencils (if the pencil will mark your hand, it's soft enough)

HOW TO START

The Shapes of Things

Everything you draw in this book will start with larger geometric shapes to get the proportions and to get everything lined up correctly. Then the details will emerge from there. One of the biggest mistakes made when drawing is starting with the outline. By the time the outline is finished, the proportions are way off.

You'll use both standard geometric shapes and free-form shapes to start:

Laying Down the Lines

You can do your preliminary drawing—and make your mistakes—on tracing paper and then transfer it to the drawing paper. If you draw directly on the drawing paper, you can keep your drawing clean by putting a piece of scrap paper under your hand so you don't smear the pencil as you work.

When you start your drawing, use light lines so you can erase. Your preliminary shapes do not need to be perfect—they are only guidelines for your final drawing. Make sure everything lines up!

Tracing paper will take a lot of erasing. To transfer your preliminary drawing, use wax-free graphite paper between the tracing paper and drawing paper. Be sure the graphite side is down!

Draw back over the lines with a colored pencil so you don't miss transferring part of it. If you don't have graphite paper, turn over your drawing and draw with your soft pencil back over the lines. Turn it right side up; place it on the drawing paper and trace back over the lines with a colored pencil. You will have a nice, clean drawing to finish.

FINISHING

To make things easier to see and follow in the book, you can use drawing pens for the final step. Below are examples of strokes you can use if you want to finish your drawing and some tricks for making your drawings look dimensional. You can stop at Step 3 of each lesson and color your drawing, if you wish, by following the color instructions for each cat. You can use crayons, colored pencils, or markers. If you use markers, color the drawing first. Then finish by drawing the lines over the color with your drawing pen. You will love the results!

You will be learning how to draw cats in this book. Some of the cats are pets of people I know. You can change the names to your own cat's name and make it look like your cat. Have fun learning how to draw cats!

Practice laying down tone with your art pen by tracing around a popsicle stick to make a tone chart. 0% is white paper and 100% is solid black. For crosshatching, use thin, parallel lines that overlap as the tone gets darker:

For stippling, use the very tip of the pen to make tiny dots. Don't bang the pen hard on the paper; use a light touch to keep the dots round. Use fewer dots farther apart for lighter areas and heavier dots closer together for dark areas.
Warning: Stippling takes a long time but is worth the effort!

Now try to make the same shape look dimensional with your strokes:

Abyssinian - "Abby"

Abyssinians have great personalities, are highly intelligent, beautiful, and make great family pets.

1. Begin with small ovals stacked on top of one another. Use an elongated oval for the body and a circle for the haunch. Long triangles form the ears. Fit in the legs and feet.

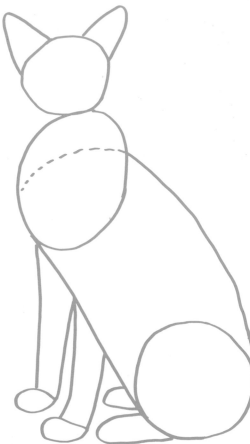

2. Connect the shapes to form a simple outline. Erase the areas where the shapes overlap, and any lines you don't need. Draw the legs up into the body. Add the facial features and pay attention to the placement of the eyes. Add the tail curling up over the other shapes.

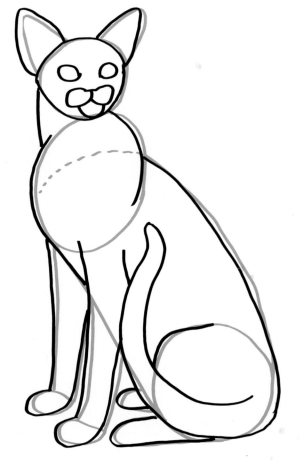

3. Detail the face and refine the outline. Indicate the areas where the tone will change dark-to-light on the legs, face, and body. Add the toes. If you want to color Abby, stop drawing at this point and switch to your colors.

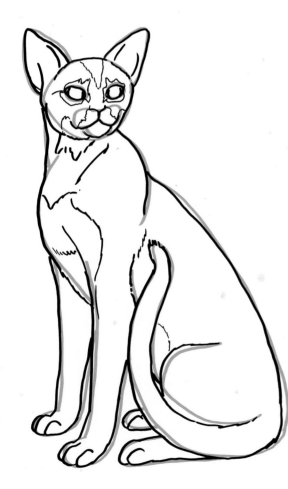

4. To finish the drawing, use short, thin strokes to make the fur. Pay attention to the direction the fur grows, especially on the tail to indicate the curl. Remember: Lighter, thinner, and fewer strokes or stippling in the white parts will indicate tone.

For Color: Abyssinians are a beautiful light coffee color with darker brown details. The back of the tail is dark.

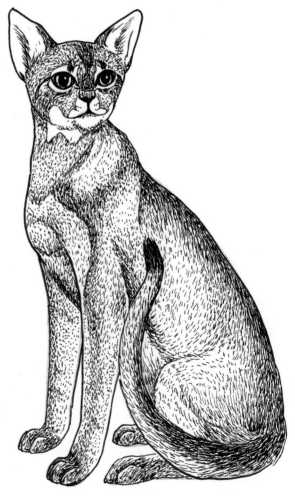

American Shorthair - "Andy"

American Shorthairs were bred long ago when the country was new. They are hearty and loving pets and can be a variety of colors and patterns.

1. Begin with a large free-form oval. Notice the placement of the head and where the other shapes fit on and into the main shape. Notice how the tip of the tail lines up with the bottom of the ear.

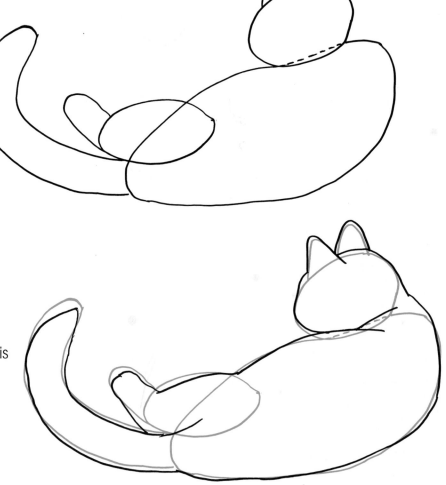

2. Connect the shapes to form a simple outline. Erase the areas where the shapes overlap, and any lines you don't need. From this angle, the main details will be in the fur.

3. Detail the face and refine the outline. Draw the foot and toes. Indicate the areas where the tone will change dark-to-white on the legs, face, and body. If you want to color Andy, stop drawing at this point and switch to your colors.

4. To finish the drawing, use short, thin strokes to make the fur, paying attention to the direction the fur grows. Leave the areas white where the light is hitting. Use heavier strokes for the darker areas and lighter, thinner strokes for the medium tones,

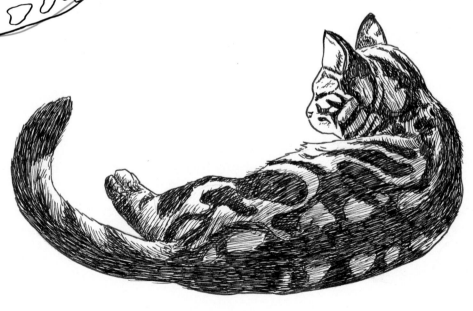

Russian Blue – "Blue"

Russian Blues are beautiful, friendly, intelligent pets. They are named for their dark blue-gray double fur coat.

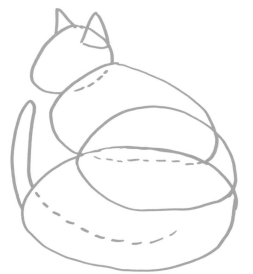

1. Begin with a pile of squatty ovals piled up like a snowman toppling over. Notice how the ear closest to you is near the back of the head, and how the tail nearly touches the nose.

2. Connect the shapes to form a simple outline. Erase the areas where the shapes overlap, and any lines you don't need. Draw in the legs and the facial features. Notice how the eye lines up under the far ear. Bring the line of the tail around from the back of the body.

3. Detail the face and refine the outline. Draw in the toes and footpads. Notice the fourth foot. Indicate where the tone will change when the light hits it, remembering that this cat is one solid color. If you want to color Blue, stop drawing at this point and switch to your colors.

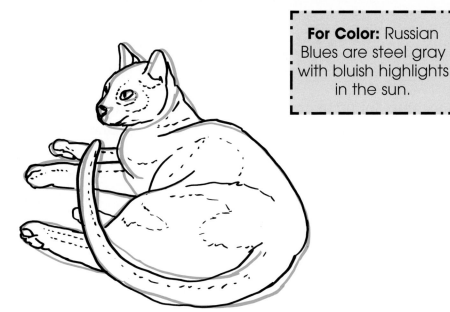

4. To finish the drawing, use very short, thin strokes to make the fur, paying attention to the direction the fur grows and to the highlight areas. Use the same stroke in the dark areas as in the light ones; just use more strokes closer together to make the fur look realistic. Notice the dark line around the eye.

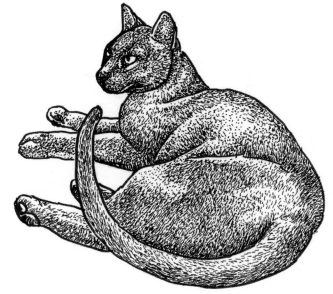

Chartreux - "Charlie"

Chartreux (pronounced shar-TROOZ) is a cat of a different color. The Chartreux has a dark bluish tint to its beautiful fur and is an affectionate pet.

1. Begin with a large egg shape. Notice how and where the other shapes fit on and in the main shape and how the head is tipped. Use triangles for the ears and ovals for the feet.

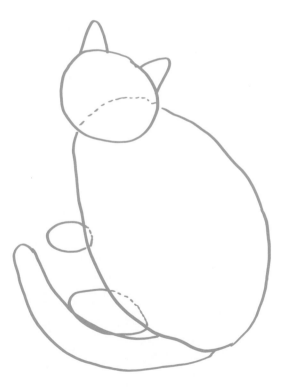

2. Connect the shapes to form a simple outline. Erase the areas where the shapes overlap, and any lines you don't need. Notice the eyes are at the same angle as the ears. Place the nose and shape the ears. Draw the haunch and notice how the knee touches the front leg.

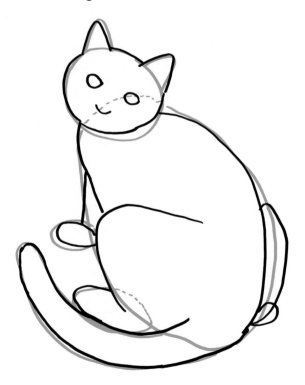

3. Detail the face, toes, and refine the outline. If you want to color Charlie, stop drawing at this point and switch to your colors.

Note: To indicate volume (roundness,) make sure you use curved lines around the body instead of straight up-and-down, which will flatten out the shape.

4. To finish the drawing, use short strokes to make the fur, paying attention to the direction the fur grows, especially on the tail.

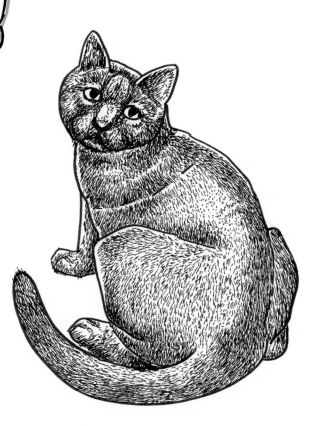

Persian - "Dolly"

Persians are known for their long, luxurious coats. Their facial features are also distinctive, with a flattened face, button nose, and small ears; they almost look like a teddy bear.

1. Begin with a large oval for the body. Notice how and where the other shapes fit on and in the main shape. Persians have very large heads and very small ears. A bean shape will get the tail started. Use ovals for the feet. Use overlapping circles to start the facial details. This step will be helpful to shape the distinctive face.

2. Connect the shapes to form a simple outline. Erase the areas where the shapes overlap, and any lines you don't need. Notice how the head and chest are almost heart-shaped. Draw the front legs up into the body. Draw the line down into the tail to indicate the curl forward. Add the back foot. Notice the detail on the face and how the cat almost looks angry.

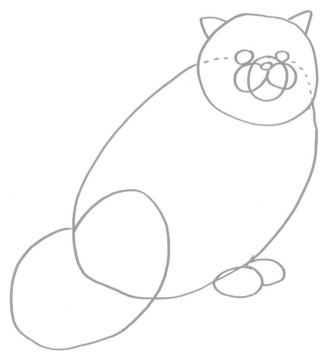

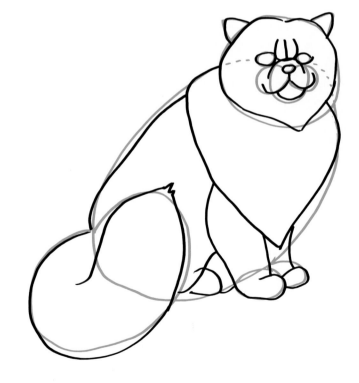

3. Detail the face, toes, and refine the outline. If you want to color Dolly, stop drawing at this point and switch to your colors. Dolly is a white Persian, but you can make her any color you want.

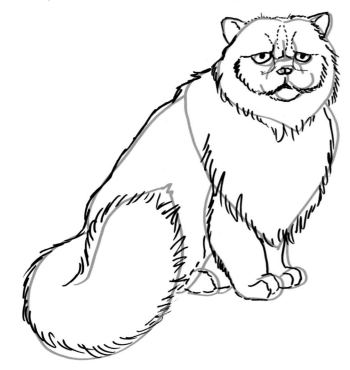

Remember: Lining up all your shapes in the right spot will result in work you will be very happy with! Take the extra few minutes in the first steps to make sure everything is in the right place. Draw, erase, and draw again!

4. To finish the drawing, use long strokes to indicate the fur, paying close attention to the direction of the strokes on the tail. Stipple in the eyes and inside the ears.

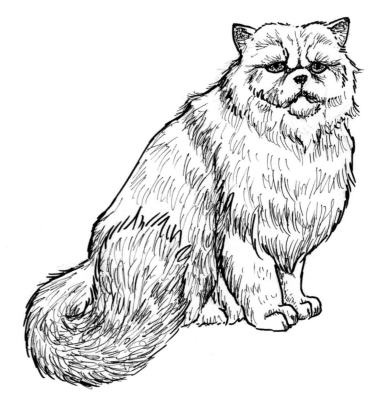

Norwegian Forest Cats were naturally bred in very harsh conditions and have a double coat. Their fur has a water-resistant layer on the outside and a thick undercoat to keep them warm.

1. Start with a long oval that's kind of flat on the bottom. The head is placed all the way to the left on top of the oval with small triangles for the ears. The feet are indicated by two ovals placed as shown.

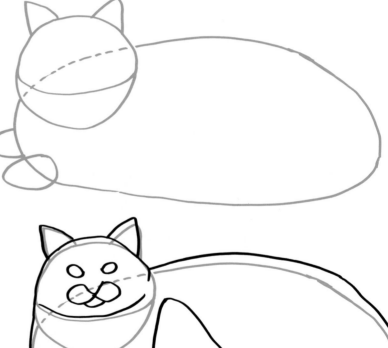

2. Connect the shapes to form a simple outline. Erase the areas where the shapes overlap, and any lines you don't need. Place the eyes and nose. Shape the ears. Draw the front leg across the bottom of the body. Add the long, thick tail curling up and around. Add the eyes, nose, and mouth.

3. Detail the face, toes, and refine the outline. Draw in some light lines where the tone will change on the legs, face and chest. Draw the toes. Broken lines around the margin tell us this is a very furry cat! If you want to color Figaro, stop drawing and switch to your colors.

4. To finish the drawing, use long strokes, paying special attention to the direction the fur grows. Figaro's tail is dark like his body, so make sure you leave a white margin around the tail so you don't end up with a blob.

For Color:
Norwegian Forest Cats can be any color. Figaro is black and white.

Maine Coon Cat - "Kashi"

Maine Coon Cats are the oldest American breed, and one of the largest. The breed gets its name because the tails are so large and fluffy they resemble raccoon tails. Maine Coons have a distinctive "M" shape between their eyes.

1. Start with a large oval. See how the head is near the center of the main oval! This is important to make the viewer believe he is looking down on the cat. Notice that the placement of the facial features is near the bottom of the head.

2. Connect the shapes to form a simple outline. Erase the areas where the shapes overlap, and any lines you don't need. Refine the ears and nose. Shape the foot and add the tail shape. Leave some of the edges loose and furry.

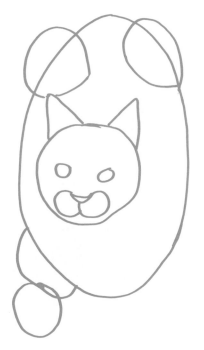

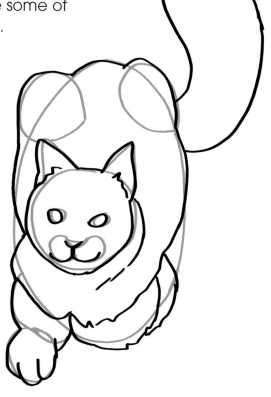

18

3. Detail the face and add the long tufts of fur on the ears. Indicate with a light line where color will change on the face. If you want to color Kashi, stop drawing at this point and switch to your colors.

For Color: Maine Coon Cats can be any cat color.

4. To finish the drawing, start with the dark pattern on the face. Make sure you leave the "M" shape between the eyes! Use long, loose, curving strokes for the fur, paying attention to the direction the fur grows.

Orange Tabby - "Louie"

Orange Tabbies are also referred to as "tiger-striped" because of their orange color and striped pattern. "Orange" tabbies refer more to color and can be any breed.

1. Louie is napping in the sun. He looks very comfortable! Begin with a large oval. A circle starts his head, and rounded triangles place his ears. The folded front paw starts right under his chin. Notice the placement of the ovals for the legs, feet, and tail.

2. Connect the shapes to form a simple outline. Erase the areas where the shapes overlap, and any lines you don't need. Indicate the nose, ears, and eyes. Pay attention to which parts overlap.

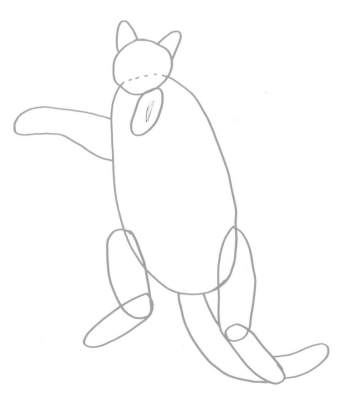

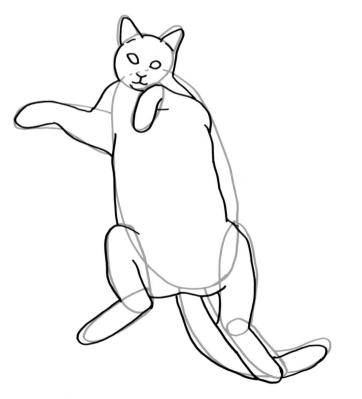

3. Detail the face and add all the margins where the tones will change. Draw in the toes and paw pads. If you want to color Louie, stop drawing now and switch to your colors.

Note: You can make any of the poses into any kind of cat you want by changing the details. Follow the instructions in any of the lessons to change ear shape and size, fur length, or coat color and pattern.

4. While Louie is an orange tabby with stripes, his belly is solid light beige. His stripes are apparent only on the legs, tail, and face. Draw in the shadow to make him look like he's sleeping in the sun.

For Color: Orange tabbies are light reddish with copper-colored stripes.

21

Manx - "Maxi"

Manx cats are born without tails, unlike some dog species that get their tails cropped.

1. Begin with a large oval shape, with a round head in the upper left corner. Notice how and where the other shapes fit on and in the main shape. Use triangles for the ears, varying shapes for the legs, ovals for the feet, and a half-circle for the stumpy tail.

2. Connect the shapes to form a simple outline. Erase the areas where the shapes overlap, and any lines you don't need. Add the eyes, nose, and mouth. Shape the ears. Draw the legs as shown.

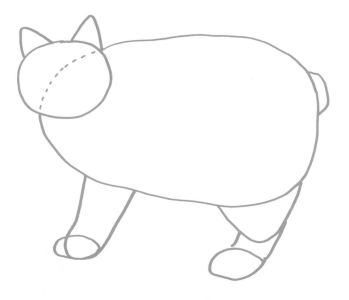

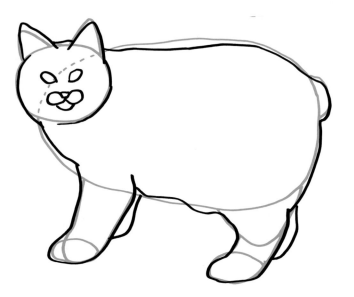

3. Detail the eyes, ears, toes, and refine the outline. Indicate the darker areas of tone. If you want to color Maxi, stop drawing at this point and switch to your colors.

Tip: If you're having trouble figuring out what's wrong with your drawing, walk away from it and come back to it, or hold it up to a mirror. The mistakes will jump out at you!

For Color: Manx cats can be any color. Maxi is white with chocolate brown spots and mask on his face.

4. To finish the drawing, detail the eyes and nose and leave a sparkle in the eyes. Use medium strokes to make the fur, paying attention to the direction the fur grows.

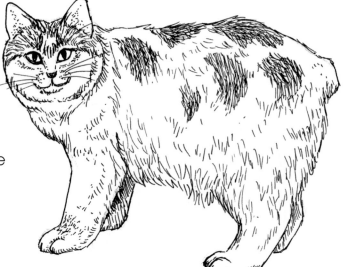

Siamese - "Miss Muffet"

Siamese are slender, beautiful, intelligent, and loving cats. There are many varieties of color for the "points," meaning the face, ears, legs, and tail.

1. Begin with an oval for the body and a circle for the head. Use long "hot dog" shapes for the legs and ovals for the feet. Notice the shape of the ears.

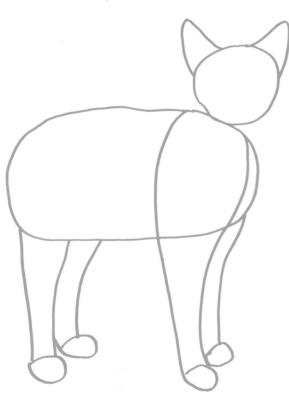

2. Connect the shapes to form a simple outline. Erase the areas where the shapes overlap, and any lines you don't need. Add the nose and shape the ears. Draw the front legs up into the body. Add the tail.

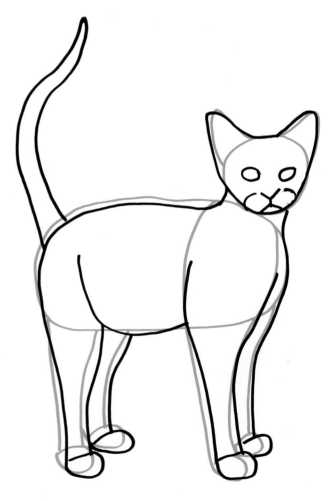

3. Detail the eyes, ears, toes, and refine the outline. Shape the legs. Indicate the "point" areas of tone. If you want to color Miss Muffet, stop drawing at this point and switch to your colors.

4. To finish the drawing, use short strokes to make the fur, paying attention to the direction the fur grows. Use more strokes closer together where the fur is darker; less and farther apart where it's light. Leave the white parts.

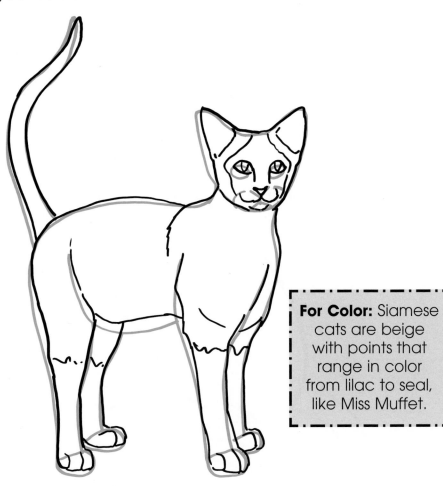

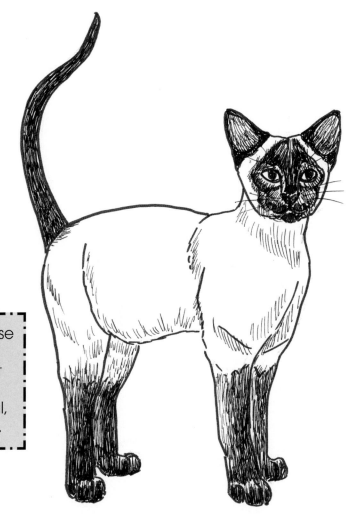

For Color: Siamese cats are beige with points that range in color from lilac to seal, like Miss Muffet.

25

Ocicat - "Ozzie"

Ocicats are a genetic "mistake." Breeders tried to cross an Abyssinian with a Siamese to get an Abby-point Siamese, and out came the Ocicat! The kitten resembled an Ocelot, so it was named "Ocicat." It is one of the few domesticated, naturally spotted species.

1. Begin with an oval for the body and a circle for the head. Connect the head to the body with two lines to form the neck. Pointy triangles form the ears. Long "hot dog" shapes form the legs and ovals form the feet.

2. Connect the shapes to form a simple outline. Erase the areas where the shapes overlap, and any lines you don't need. Add the nose, eyes, and shape the ears. Add the long tail.

3. Detail the eyes and ears and refine the outline. Refine the legs and add the toes. Here's the hard part: draw in the irregular-shaped spots and the stripes on the tail. If you want to color Ozzie, stop drawing at this point and switch to your colors.

4. To finish the drawing, detail the eyes and nose and leave a sparkle in the eye. Use medium strokes to make the fur, paying attention to the direction the fur grows. Leave the white parts white behind the spots. The last step is to darken in the spots.

For Color: Ocicats are beige to golden with dark brown to black spots in a regular pattern.

Ragamuffin - "Reggie"

Ragamuffins are very fluffy cats! Their fur makes them look bigger than they really are. Ragamuffins are sweet and lovable pets.

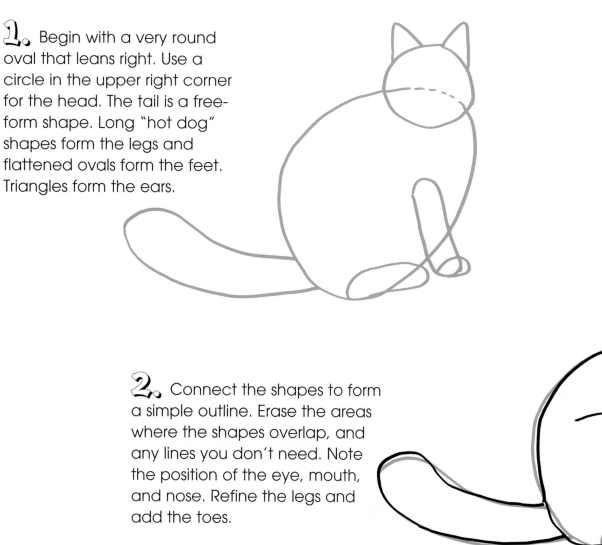

1. Begin with a very round oval that leans right. Use a circle in the upper right corner for the head. The tail is a free-form shape. Long "hot dog" shapes form the legs and flattened ovals form the feet. Triangles form the ears.

2. Connect the shapes to form a simple outline. Erase the areas where the shapes overlap, and any lines you don't need. Note the position of the eye, mouth, and nose. Refine the legs and add the toes.

3. Detail the eyes, ears, toes, and refine the outline. Indicate the mask and areas of color with light lines. If you want to color Reggie, stop drawing at this point and switch to your colors.

For Color: Reggie is gray and white, but Ragamuffins can be any cat color or pattern.

4. To finish the drawing, detail the eyes and nose. Use long strokes to create the fur, paying attention to the direction the fur grows. Leave the white parts white and pay special attention to the areas where the tones may blend together, such as the haunches and the tail. Leave a margin of lighter tone in between.

Havana Brown - "Smoky"

Havana Browns were named for their color, which is similar to a Havana cigar.

1. You are doing a portrait of Smoky, which means just her head and shoulders. Begin with a large circle for the head. Add the slanted oval eyes and triangles for the ears. Notice the shape of the parts that form the muzzle, nose, and mouth. Indicate where the back, chest, and chin will be, but you will not finish these parts.

2. Connect the shapes to form a simple outline. Erase the areas where the shapes overlap, and any lines you don't need. Note the position of the eyes and nose. Draw in the facial features.

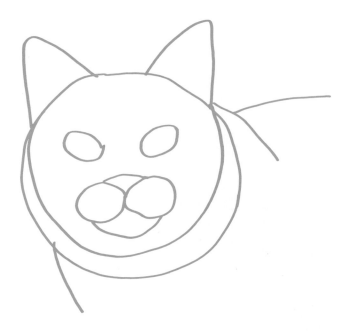

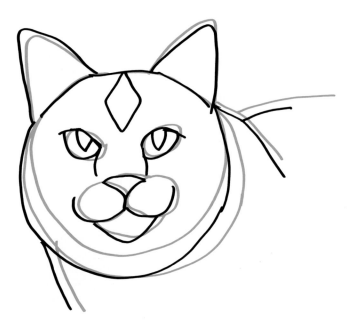

3. Detail the eyes, ears, mouth, and nose, refining the areas of tone changes. If you want to color Smoky, stop drawing at this point and switch to your colors.

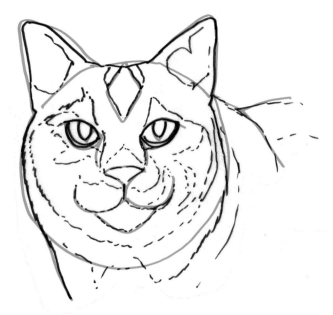

For Color: Havana Browns are deep chocolaty brown overall. Leave orangeish to reddish highlights in the lighter areas. The eyes can be green to brown.

4. To finish the drawing, detail the eyes and nose and leave a sparkle in the eye. Use short strokes to create the fur, paying attention to the direction the fur grows, and stipple in detail in the eyes and nose. Notice the layers of fur and how they recede away from the face, leaving it as the focal point.

ABOUT THE ARTIST

Robin Lee Makowski is a professional artist, illustrator, and instructor. She specializes in watercolor painting and drawing and has illustrated more than thirty children's books.

"I always loved science and nature," explains the artist. "I studied everything closely and tried to draw it. I noticed the way things lined up, how close or far away things were, the way the light hit them, and how the light affected the color."

"It's so important to learn how to draw," she insists. "You have to realize that when you can draw, you're free. All you need is a pencil and paper and you can create wherever you are. Drawing is rewarding both in the process and the product."

Robin lives in Hobe Sound, Florida, with her hus-band, two sons, and her best friend, her mutt Casey.

Visit Robin at her website: www.rlmart.com